THE FLIRTY 30's

BY

ANDREA L. WILLOW

Illustrations by Erna Esther Blatt-Solomon

THIS BOOK IS PUBLISHED BY ANDREA L. WILLOW

"The Flirty 30's". Copyright © 2013 by Andrea L. Willow. All rights reserved. Published in the United States by Andrea L. Willow. No part of this book may be reproduced by any mechanical, photographic, or electronic process, or in the form of a phonographic recording; nor may it be stored in a retrieval system, transmitted, or otherwise be copied for public use without prior written permission of the author and publisher.

The intent of the author is only to offer inspiration and memories via her Mother's artwork.

Book cover is designed by Mary D. Scott using
Illustrations by Erna Esther Blatt-Solomon
Written by Andrea L. Willow

Library of Congress Cataloging-in-Publication Data available upon request.

ISBN 978-1484909034
ISBN 1484909038

Printed in the United States of America

July 2013

Dedication

This book is dedicated In Loving Memory to my Mother, Erna Esther Blatt-Solomon, who since the day I was born gave me much love. I thank her for creating for me the most incredible wardrobe a girl could ever dream of while growing up.

Acknowledgments

I would like to acknowledge my family and friends for their encouragement and support to publish this book, especially Flo Ginsburg and Mary Ruth Hughes for their input.

Mary D. Scott who formatted the interior pictures, text, book covers, and put the entire book together electronically to be published.

Author's Note:

This book contains selected drawings of my Mother's pen and ink and watercolor pieces created during the 1930's.
*- **Andrea L. Willow***

Table of Contents

Introduction..i
Chapter One – Oh Those Faces!......................................1
Chapter Two – It's a Wrap!..6
Chapter Three – An Enchanted Evening....................13
Chapter Four – Party Time!...24

Introduction

This book has been in the making subconsciously ever since I saw these wonderful drawings. My mother, Erna Esther Blatt-Solomon, drew these while attending the University of Chicago Art Institute. With great pleasure I share her fashion designs of the 1930's with you.

About the Artist

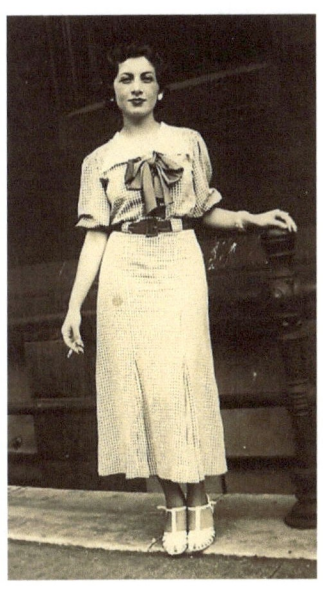

Erna Esther Blatt-Solomon

As a little girl Mom played with paper dolls and made paper doll wardrobes. Her father, Joseph Blatt, came to America in the late 1800's or early 1900's from Austria. Her mother, Bertha, came to America from Germany by herself at age 18 and met Joseph while looking for work. Bertha was a seamstress. Joseph was a professional tailor and taught my mother tailoring skills. Mom was able to make just about anything without a pattern.

Being a professional fashion designer was Mom's desire. However, her parents were against the career as they did not feel it was a secure industry. She ended up as a retail sales clerk, sprinkled with occasional window trimming for department stores.

Mom married my Dad, Manny Solomon, in the 1930's in Chicago. Then came my brother, Richard; then me. Mom pursued her creativity in many ways from decorating her home, to her gardening, to painting portraits. My dear mother, aka as the human version of the Ever-Ready battery, passed at her home on May 4, 2004 at the age of 91.

Chapter One – Oh, Those Faces!

Lovely ladies of the 1930'S
Beauty so natural,
Ah, let's get casual.

A statement for sure,
Looking bright, sophisticated, and demure.

Ruby red lips,
Soft bedroom eyes,
Lashes fluttering
Men muttering.

Loose, luscious curls
Send men spinning,
Am I winning, am I winning,
The first inning?

Pursue a sophisticated lady,
Watch out, things could get shady.

Hair pulled tight --
By the way, she is always right!

Light her cigarette if you desire,
Be careful not to set her leather
Gloves on fire.

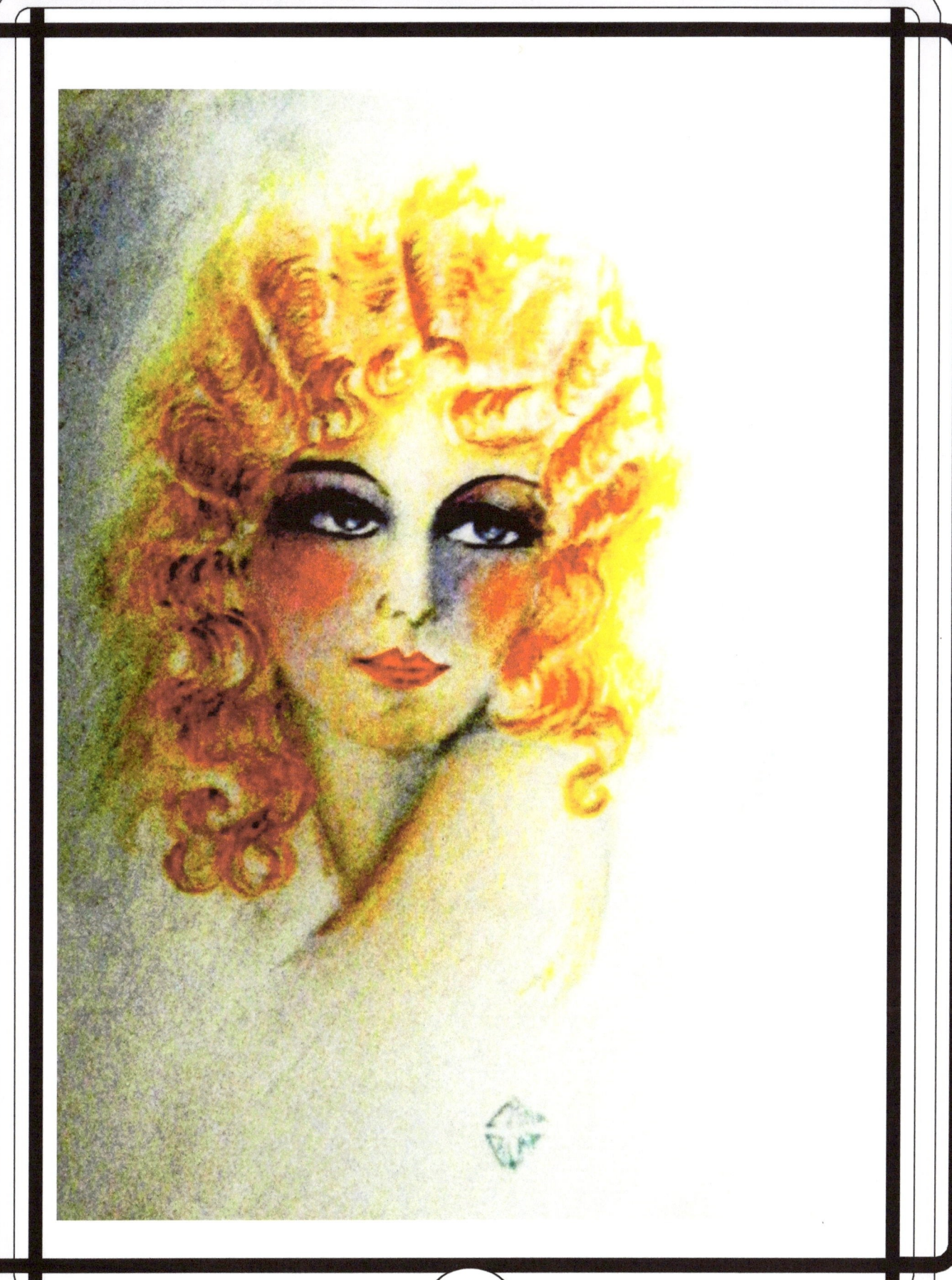

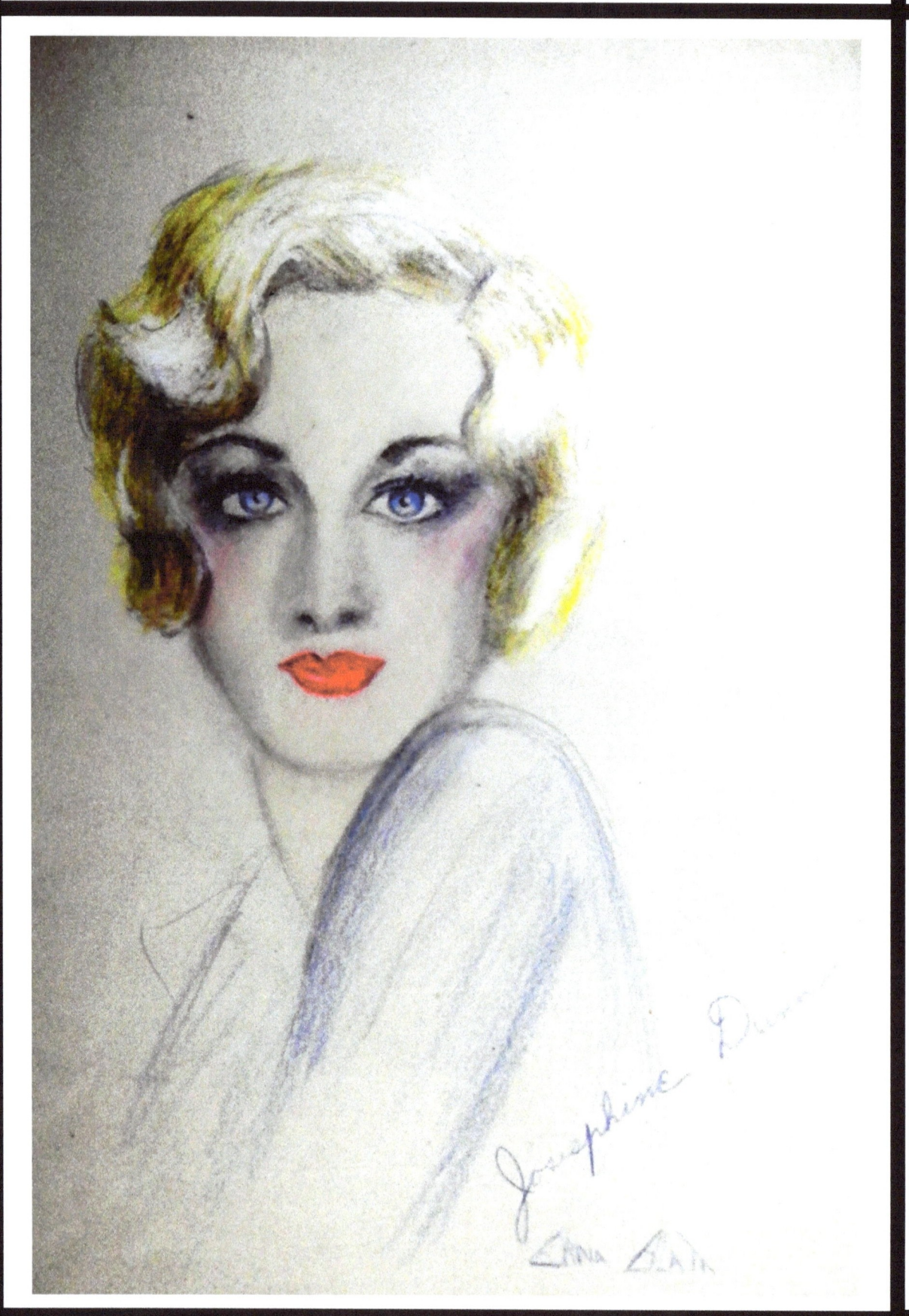

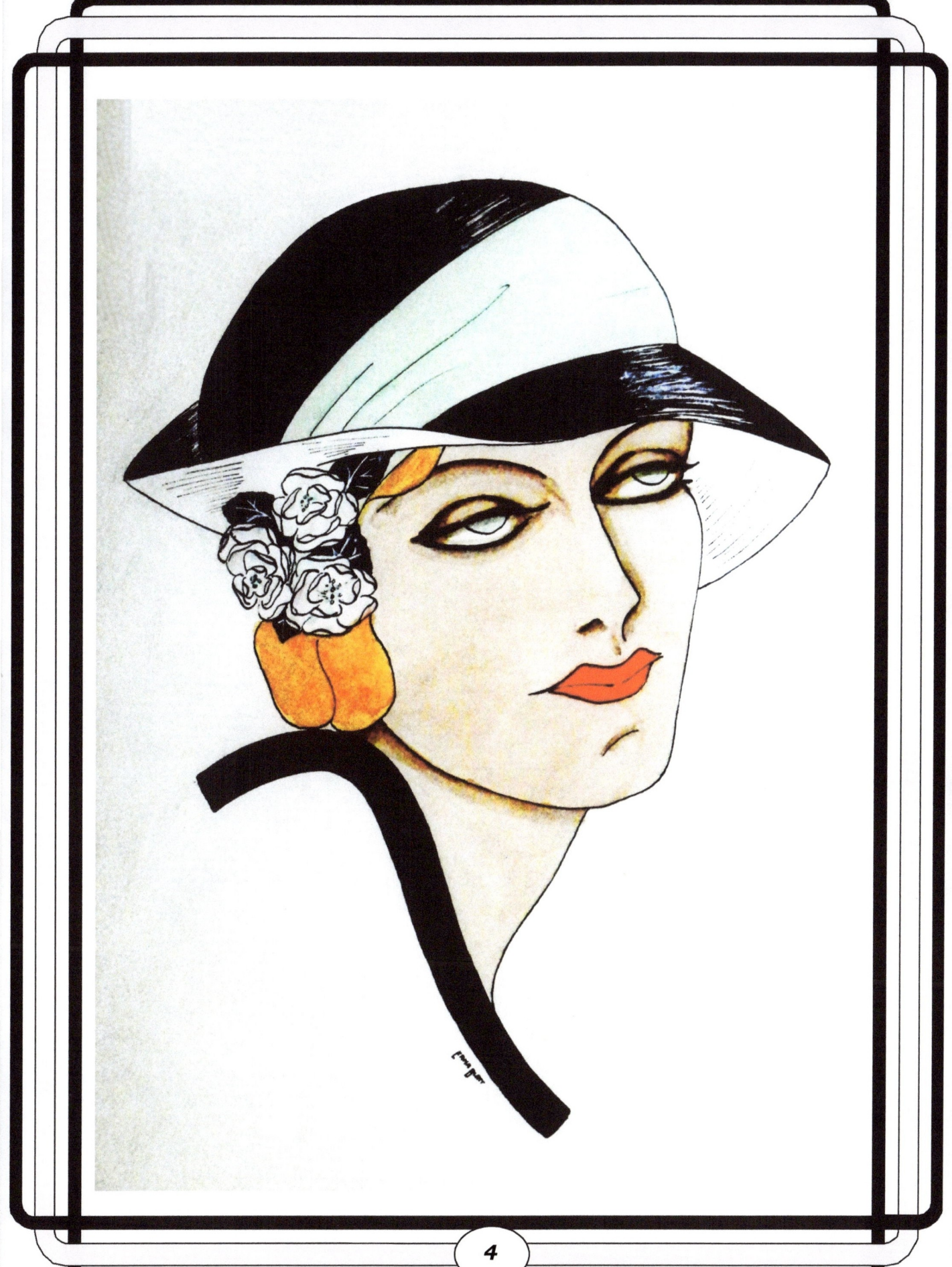

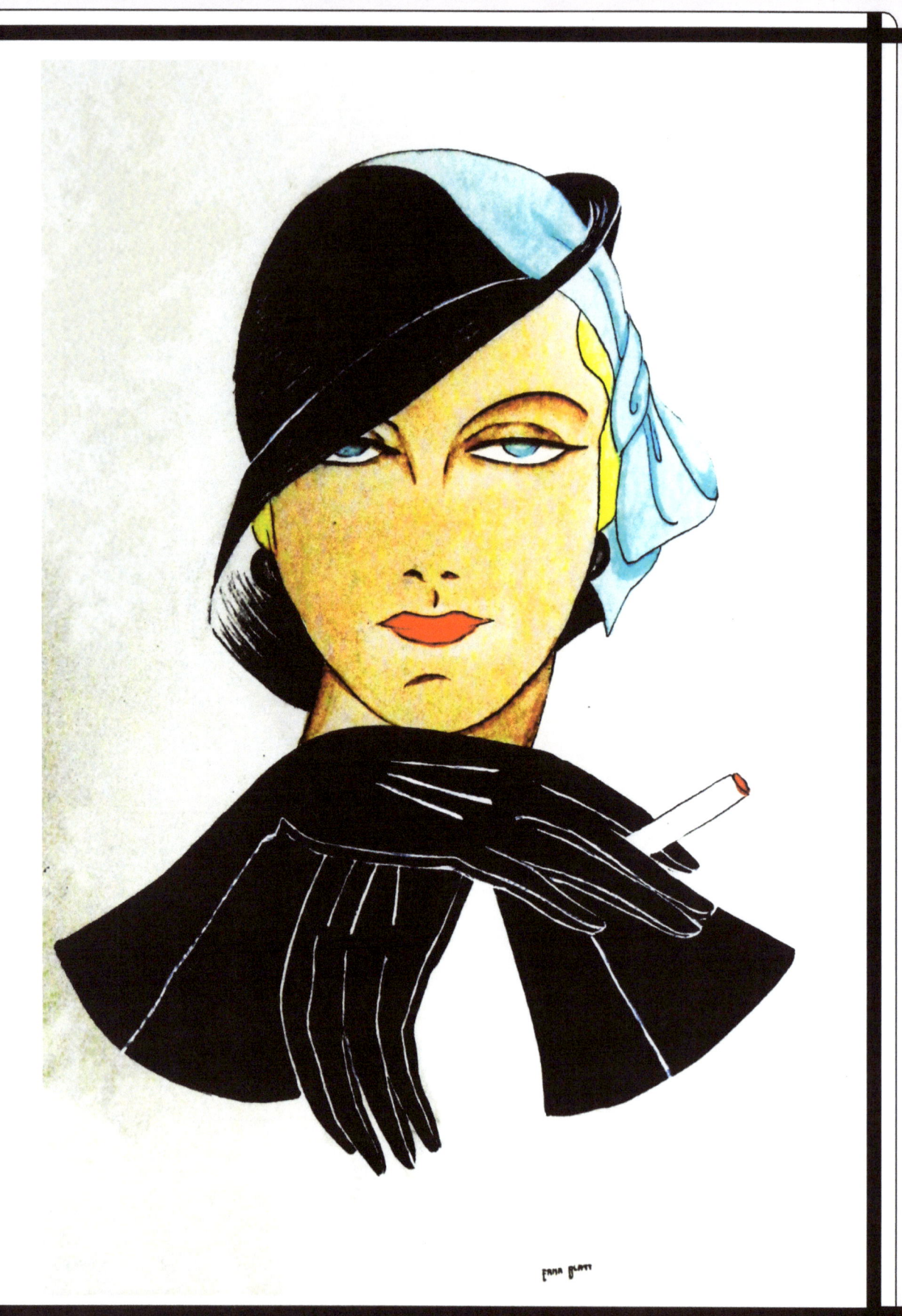

Chapter Two – It's a Wrap!

Burrrrrr, wear fur!
Pick one, pick two
Especially for you.

Foxes, minks, and other little creatures
Brings comfort on a chilly winter night.

Toss a fox over one shoulder --
Critter won't bite,
Makes coordinated delight.

Draping the perfectly tailored suit,
Looking greater than cute.

Hats, gloves, and shoes accessorize,
Any shape, any size.

Belts, buttons and box pleats,
Fashionable on swanky streets.

Cutting fabric on the bias
Creates a fashion riot,
Gives fluidity and swirl
To the then modern girl --
Watch her fancy twirl!

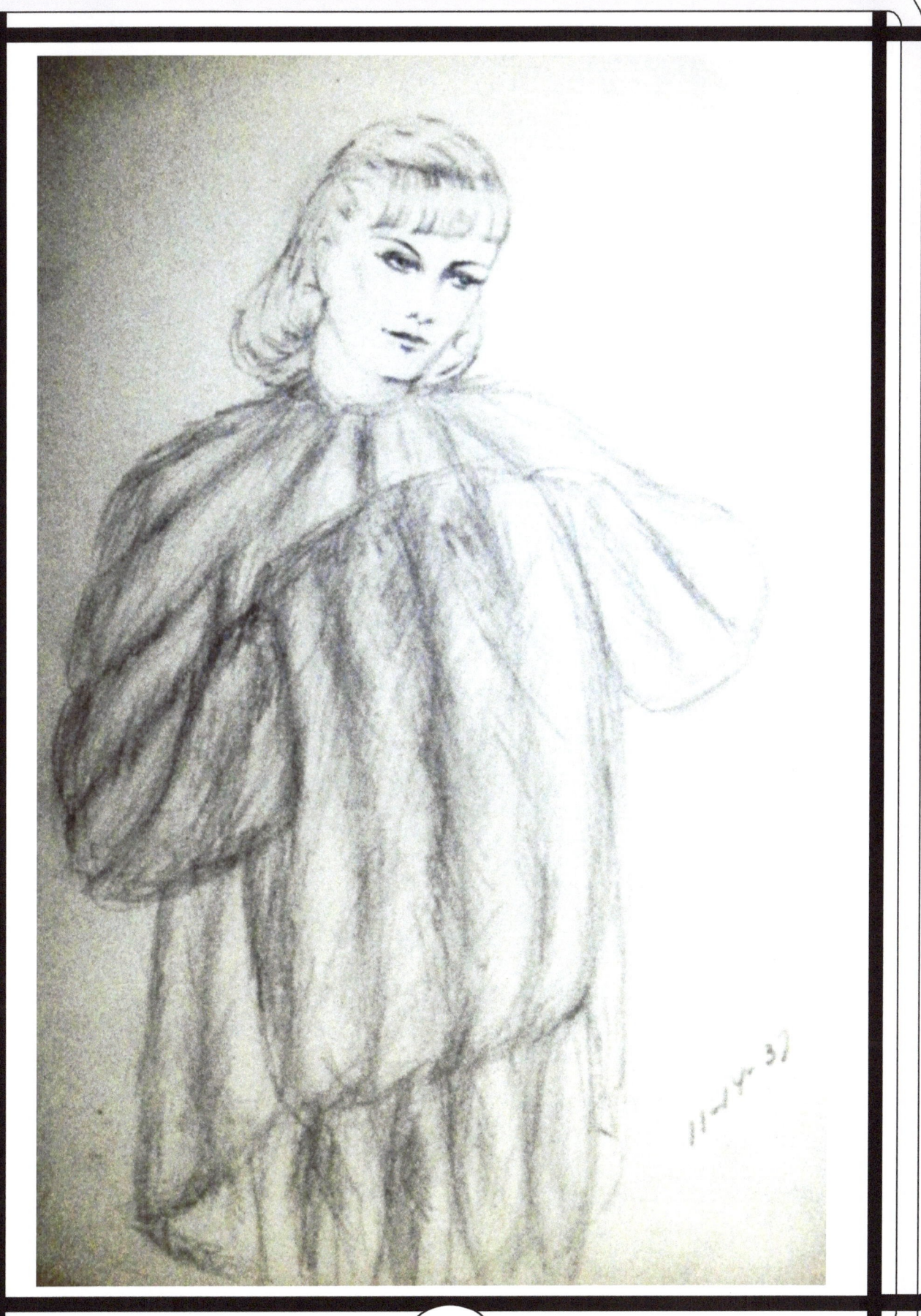

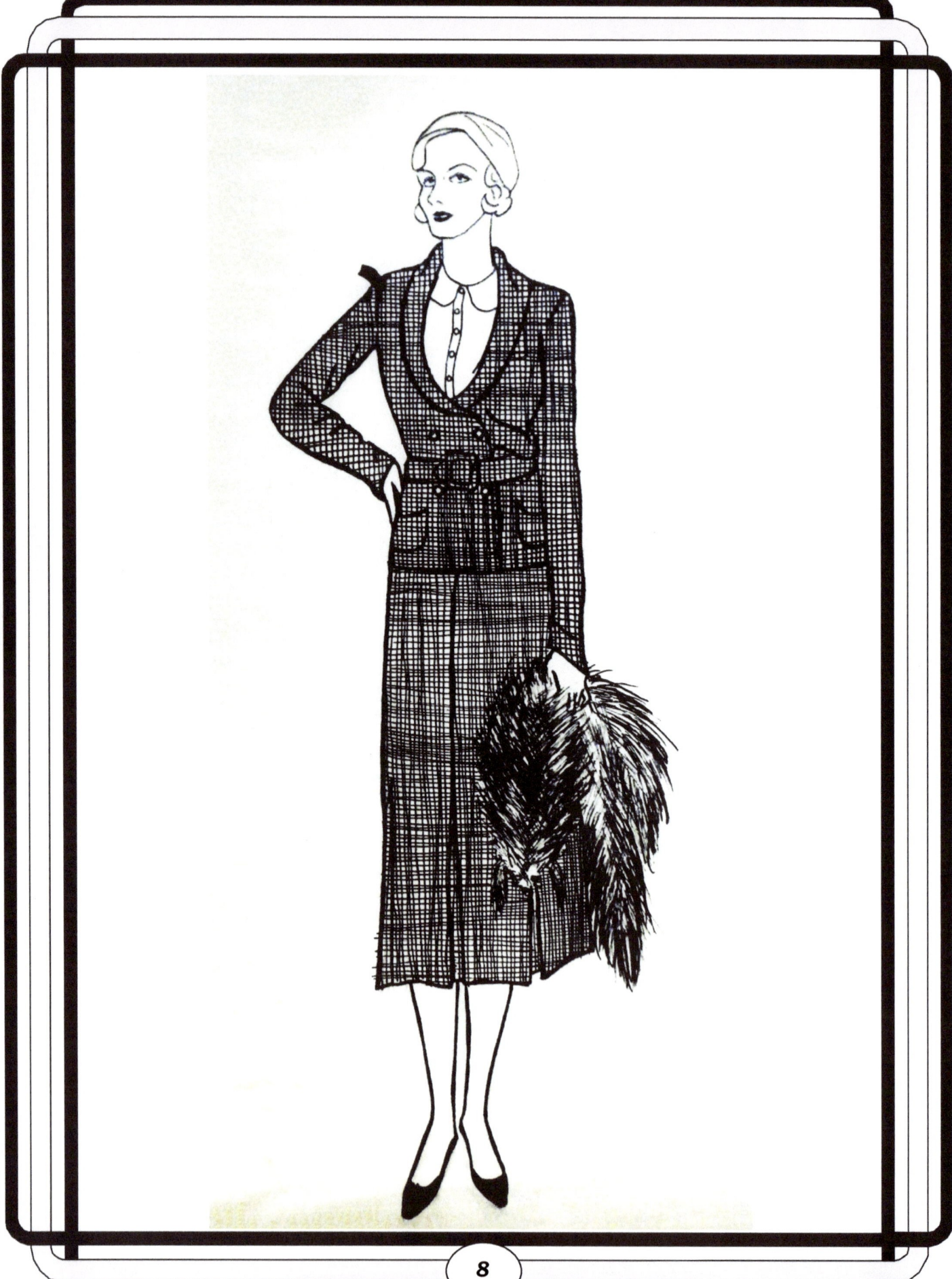

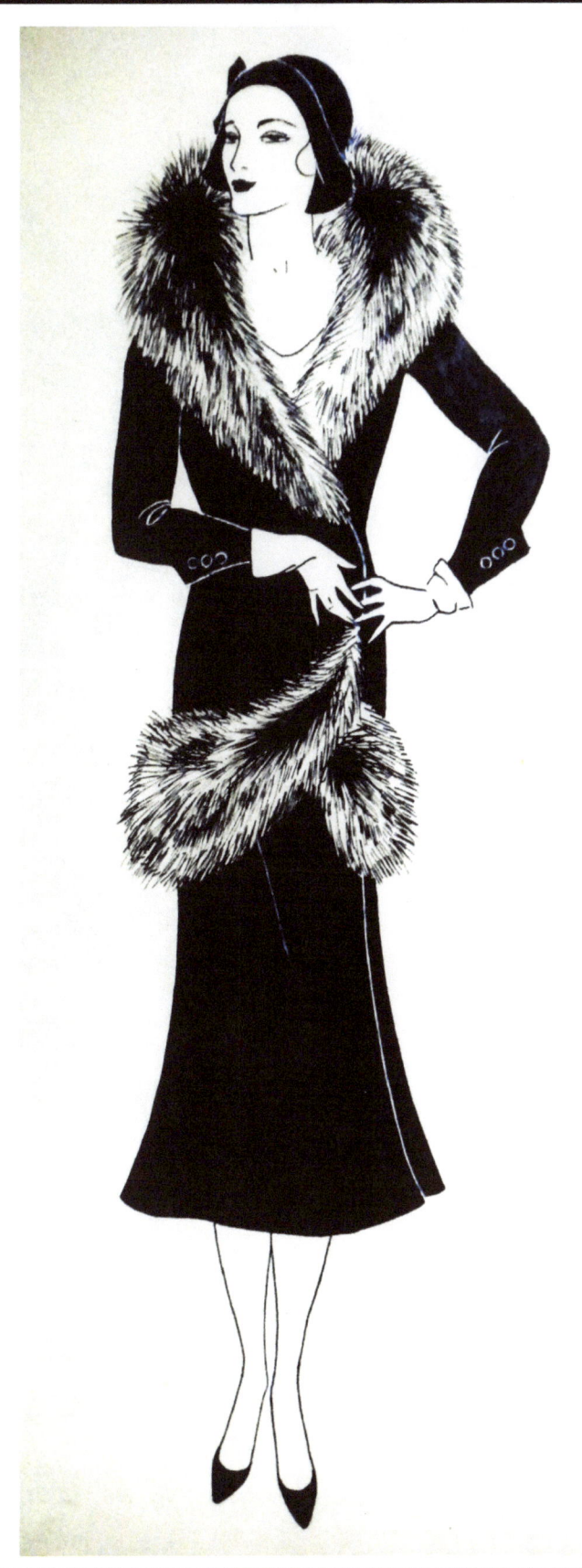

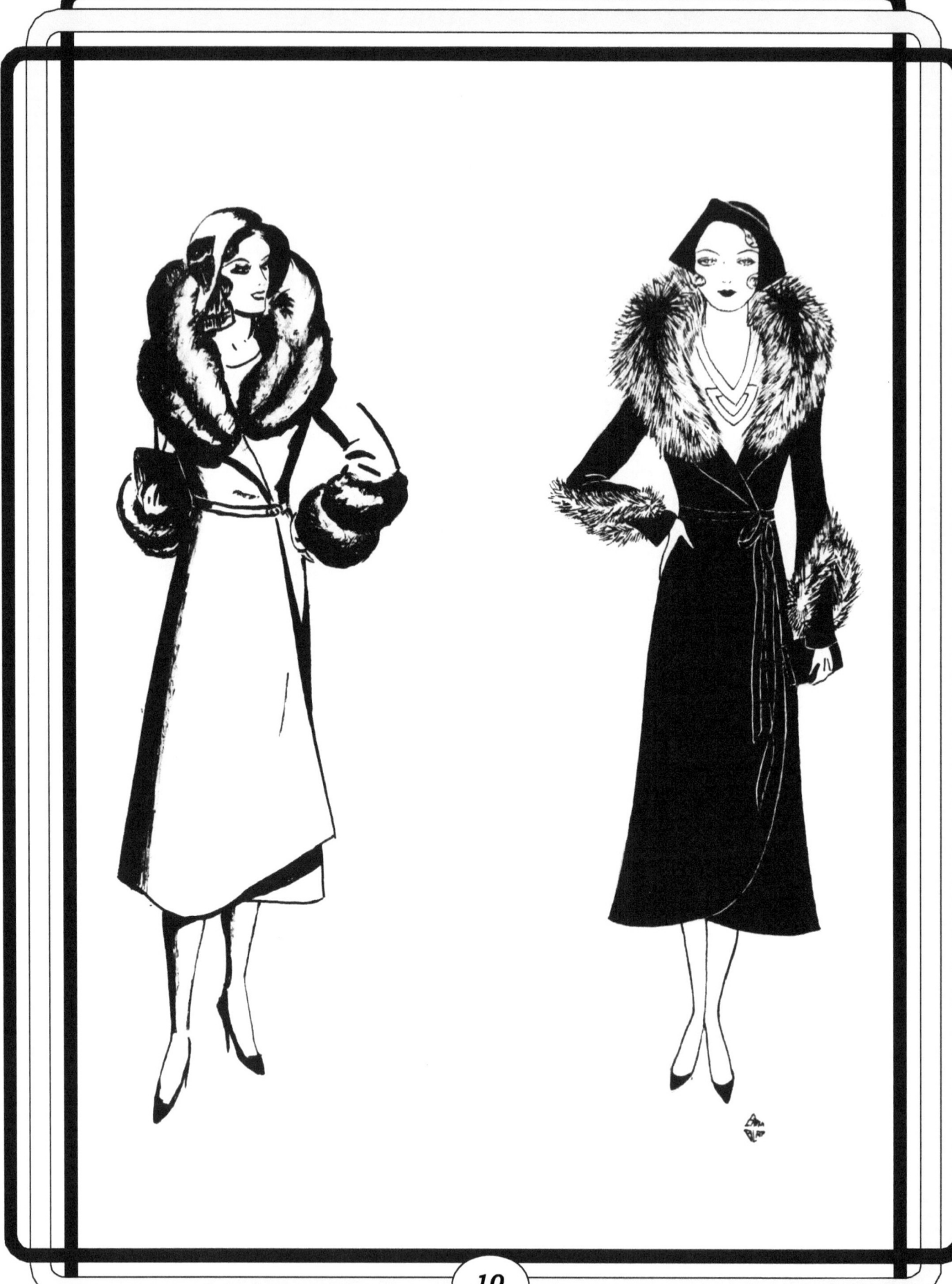

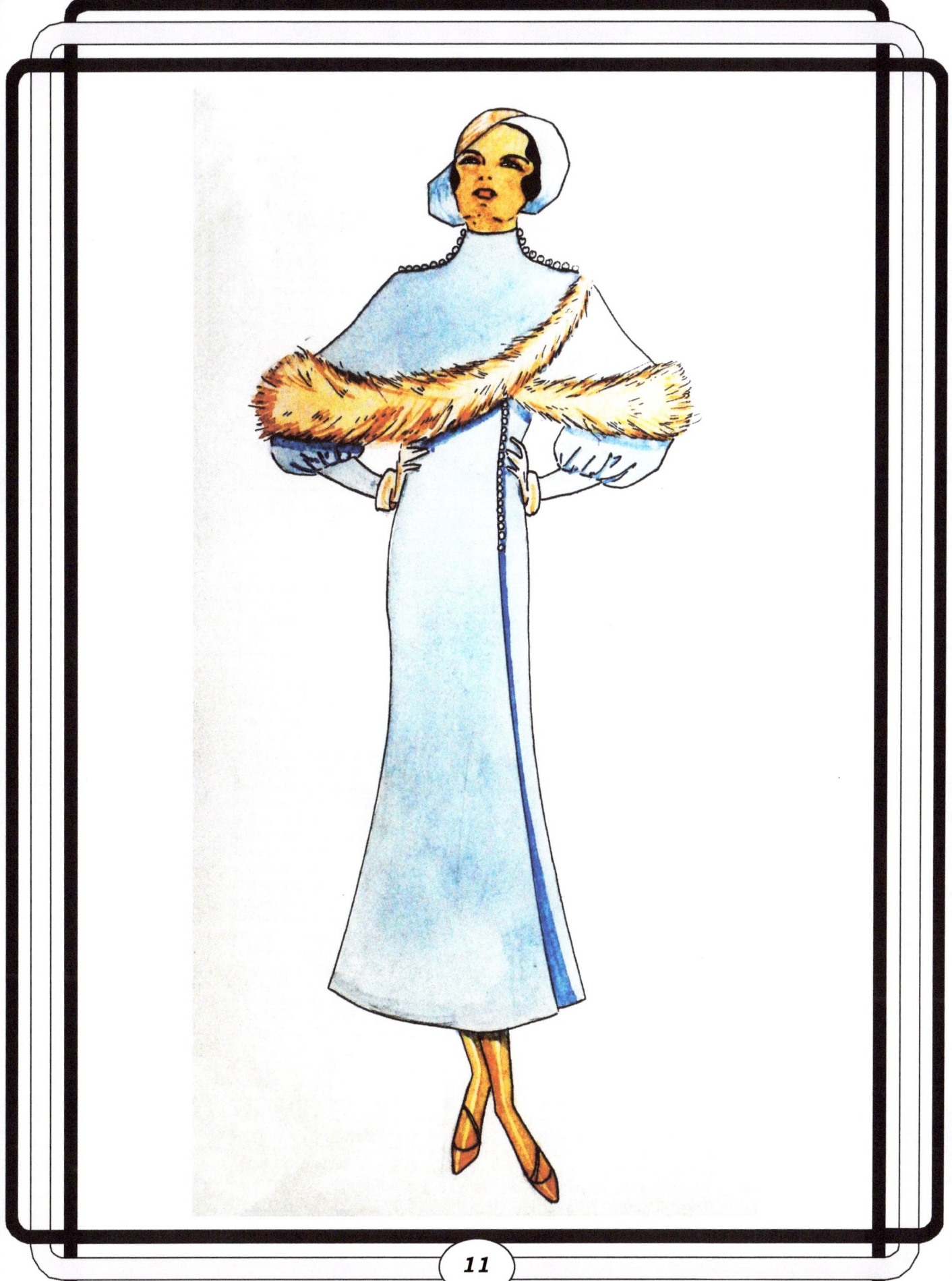

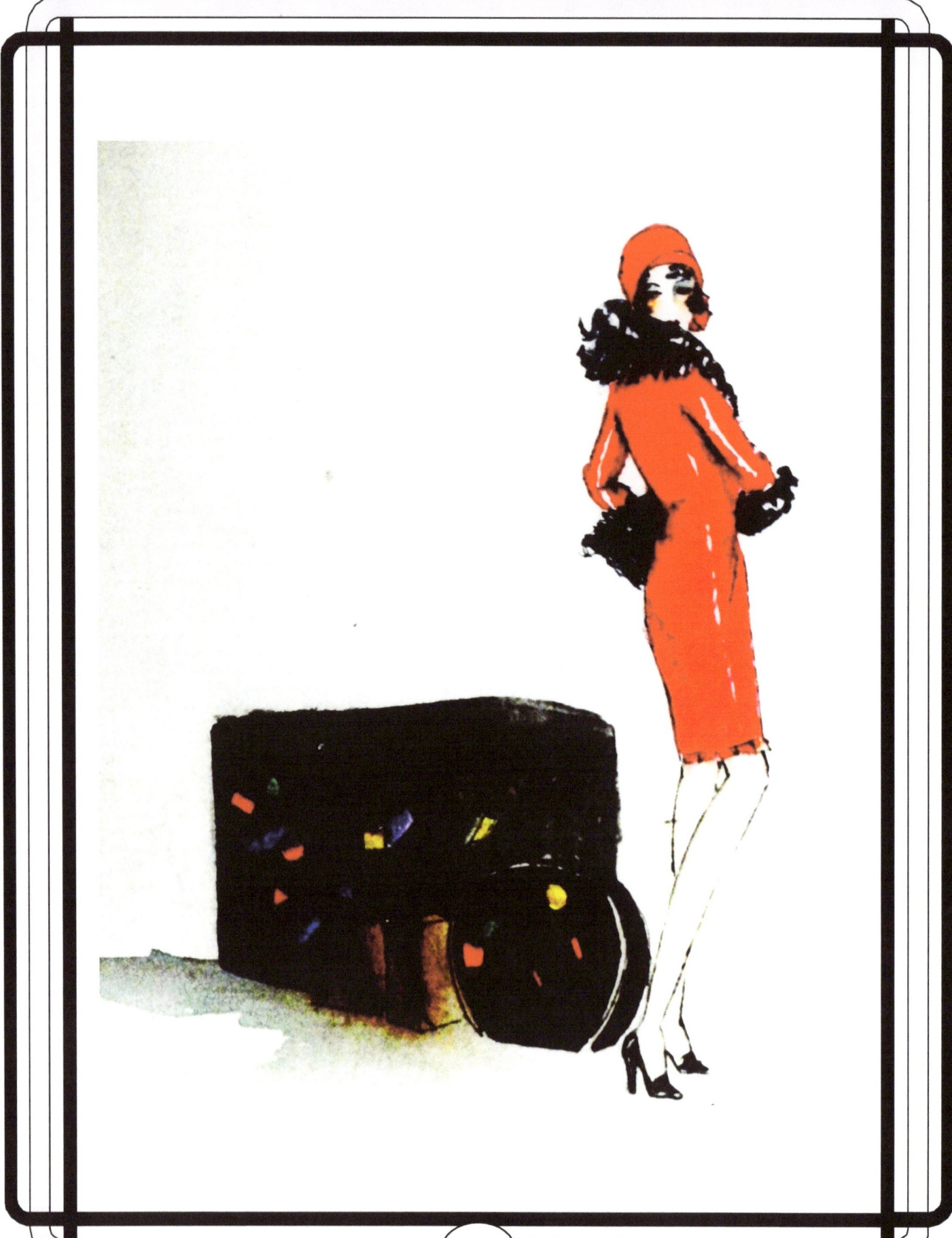

Chapter Three – An Enchanted Evening

Lights dim,
Voluptuous and thin.

Girdles in place,
Garters on call,
Who is the most popular of all?

Silks, satins and crepe-de-chine
Womanly curves appear simple and clean.

Fluffy ruffles on a skirt
Gives umph to being a flirt!

Finger waves perfectly set
Cling to cheeks
Dare to peek
Attention is what one seeks.

A brilliant, colorful shawl
For the bell of the ball.

Bows from head to toes
Is stunning to those in the knows.

Caressing a cigarette holder
Femmes look bolder!

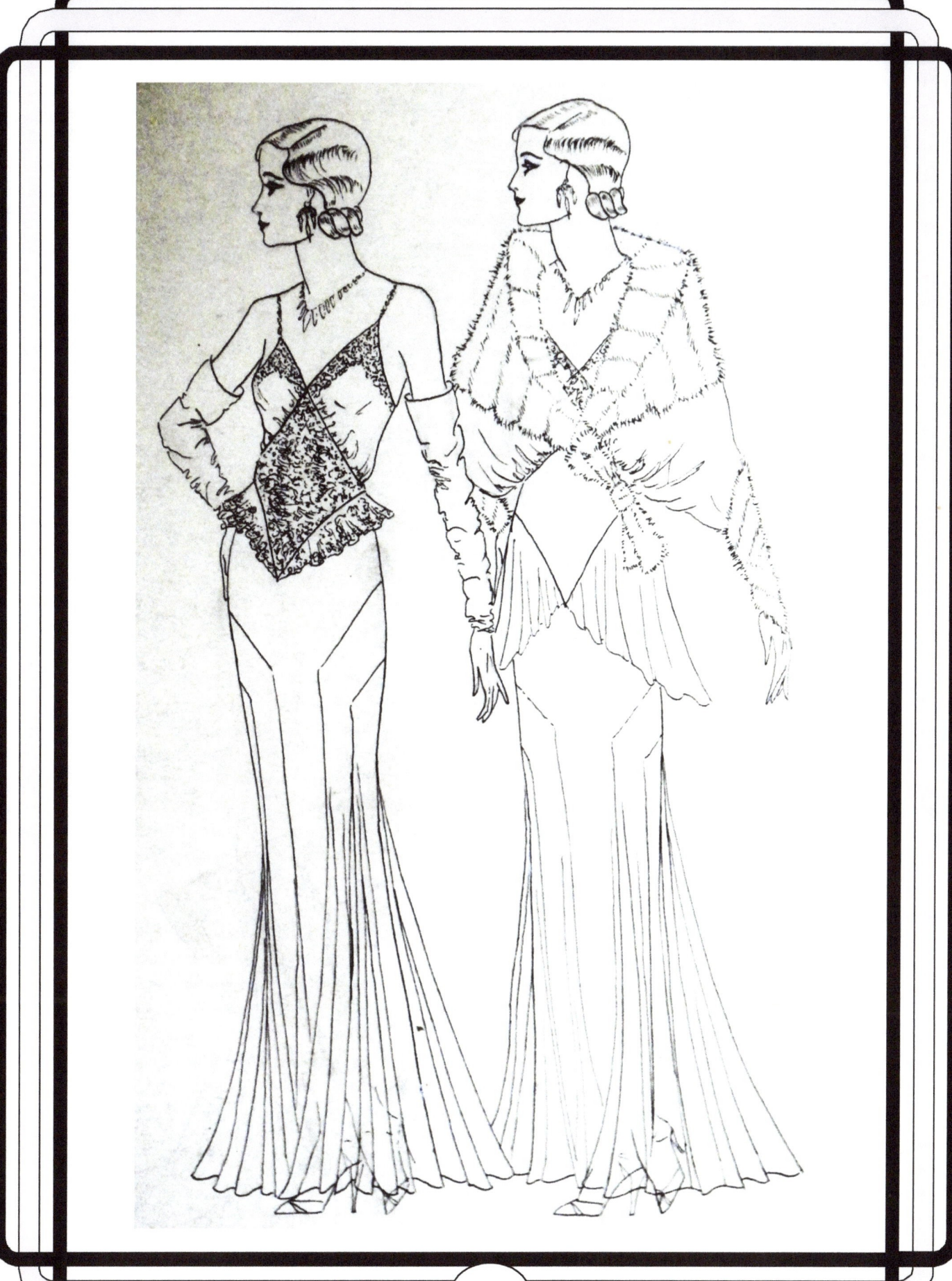

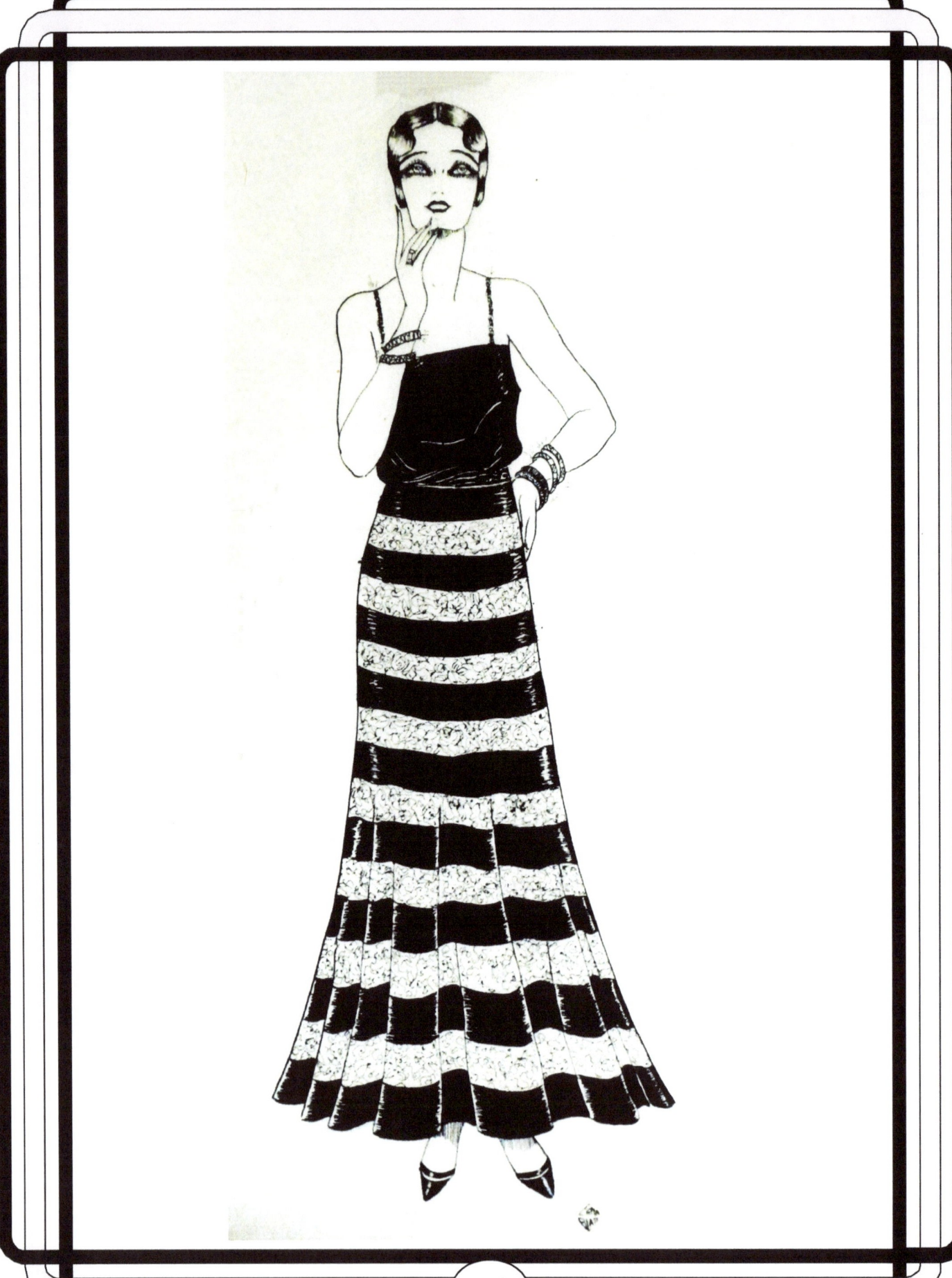

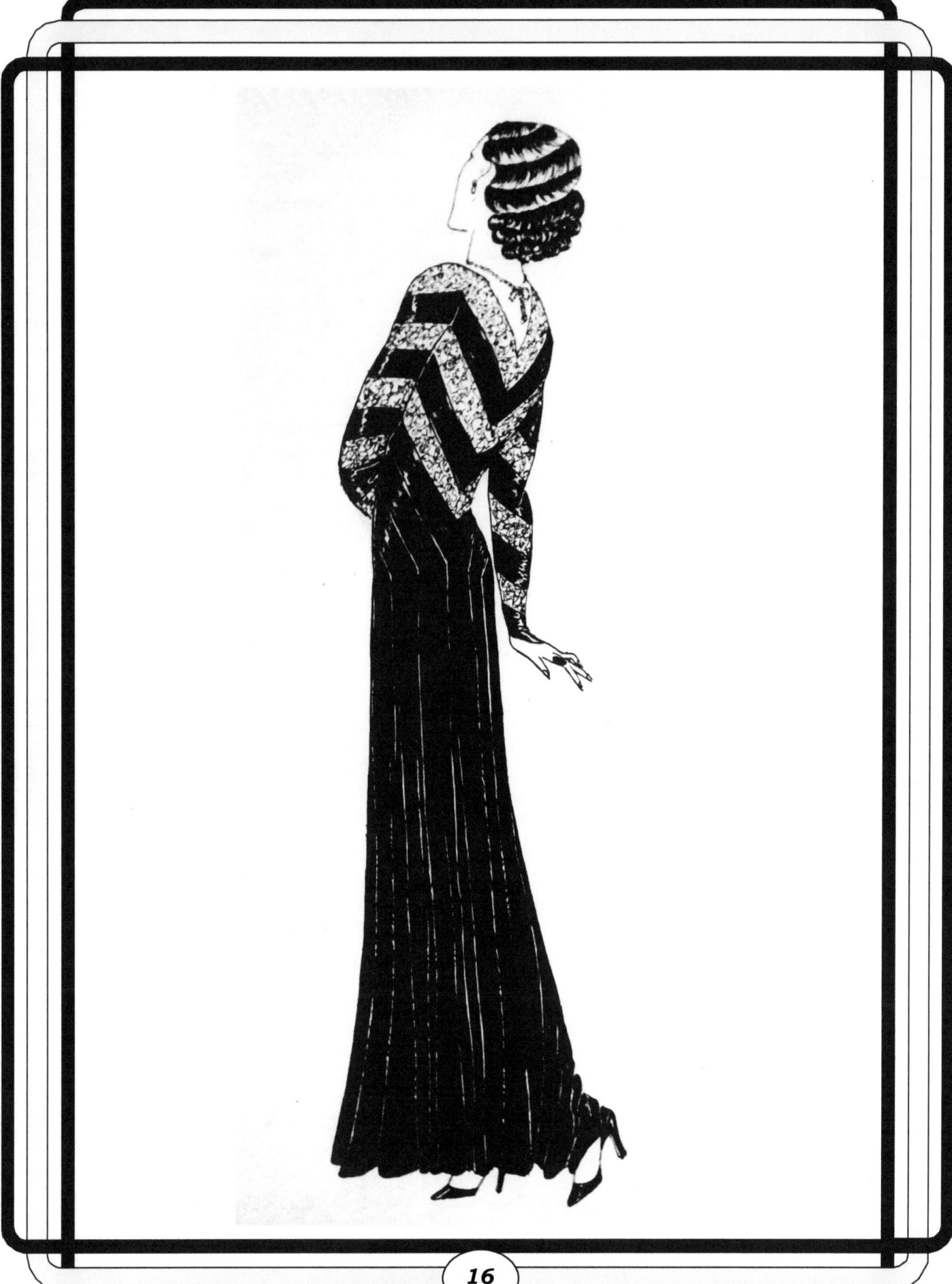

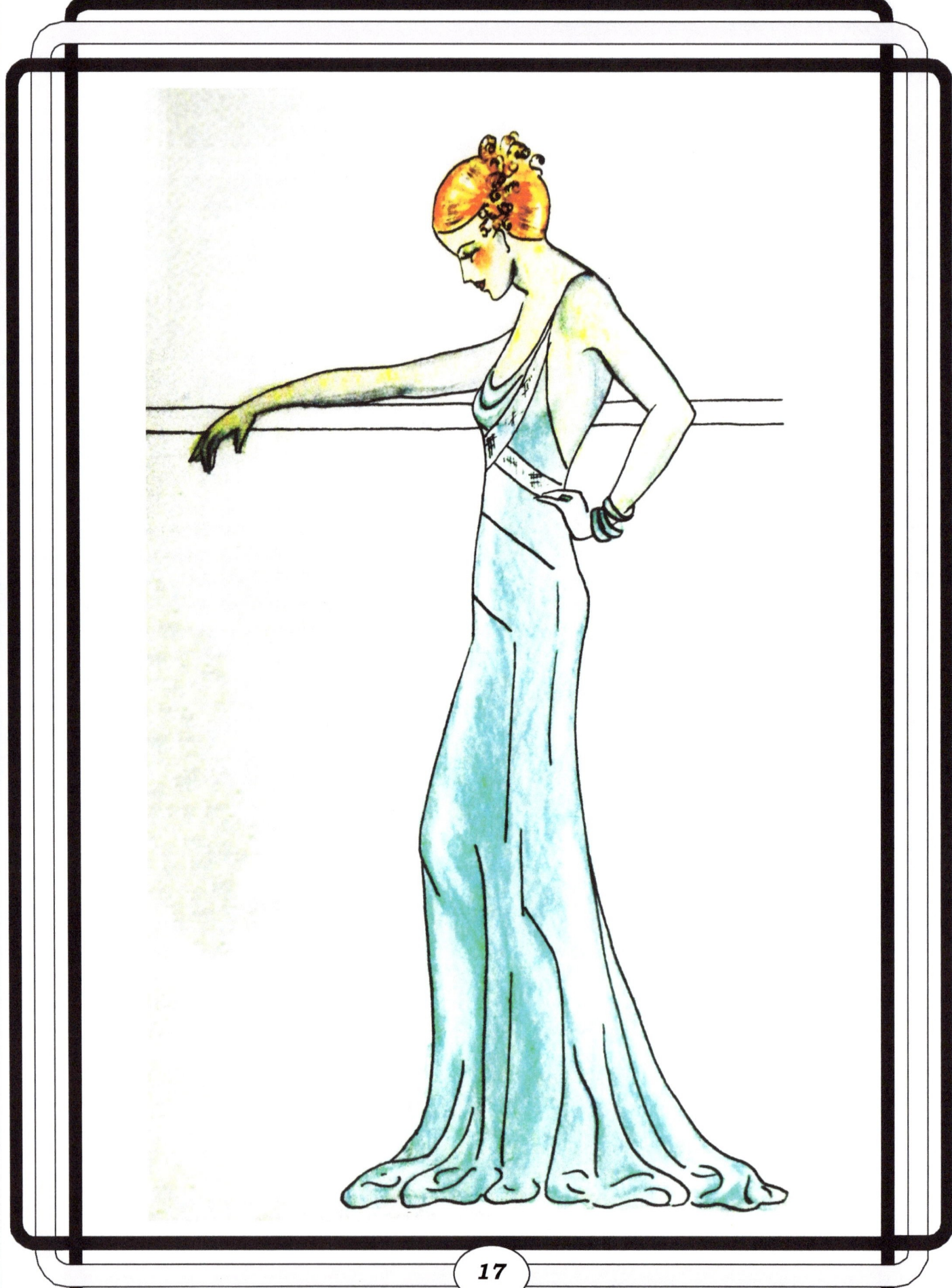

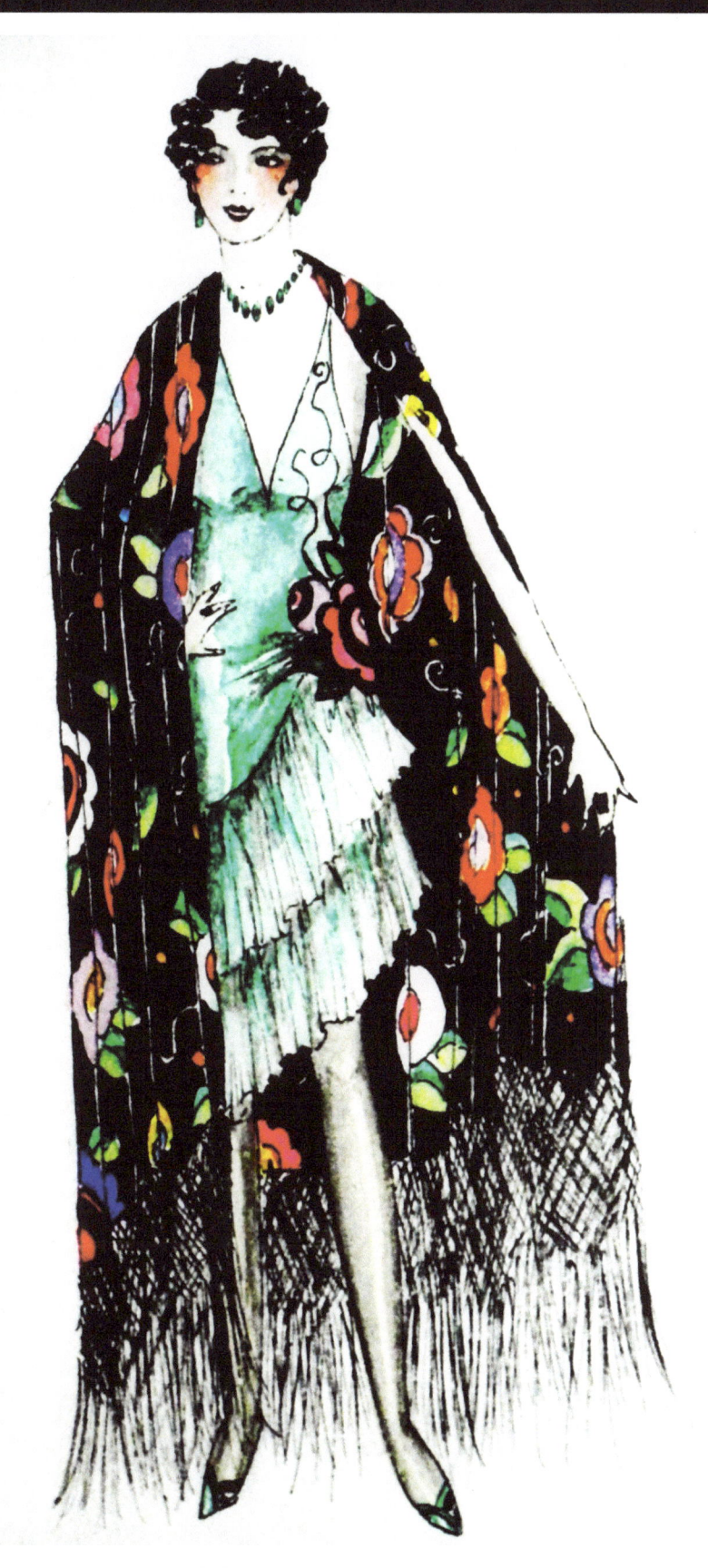

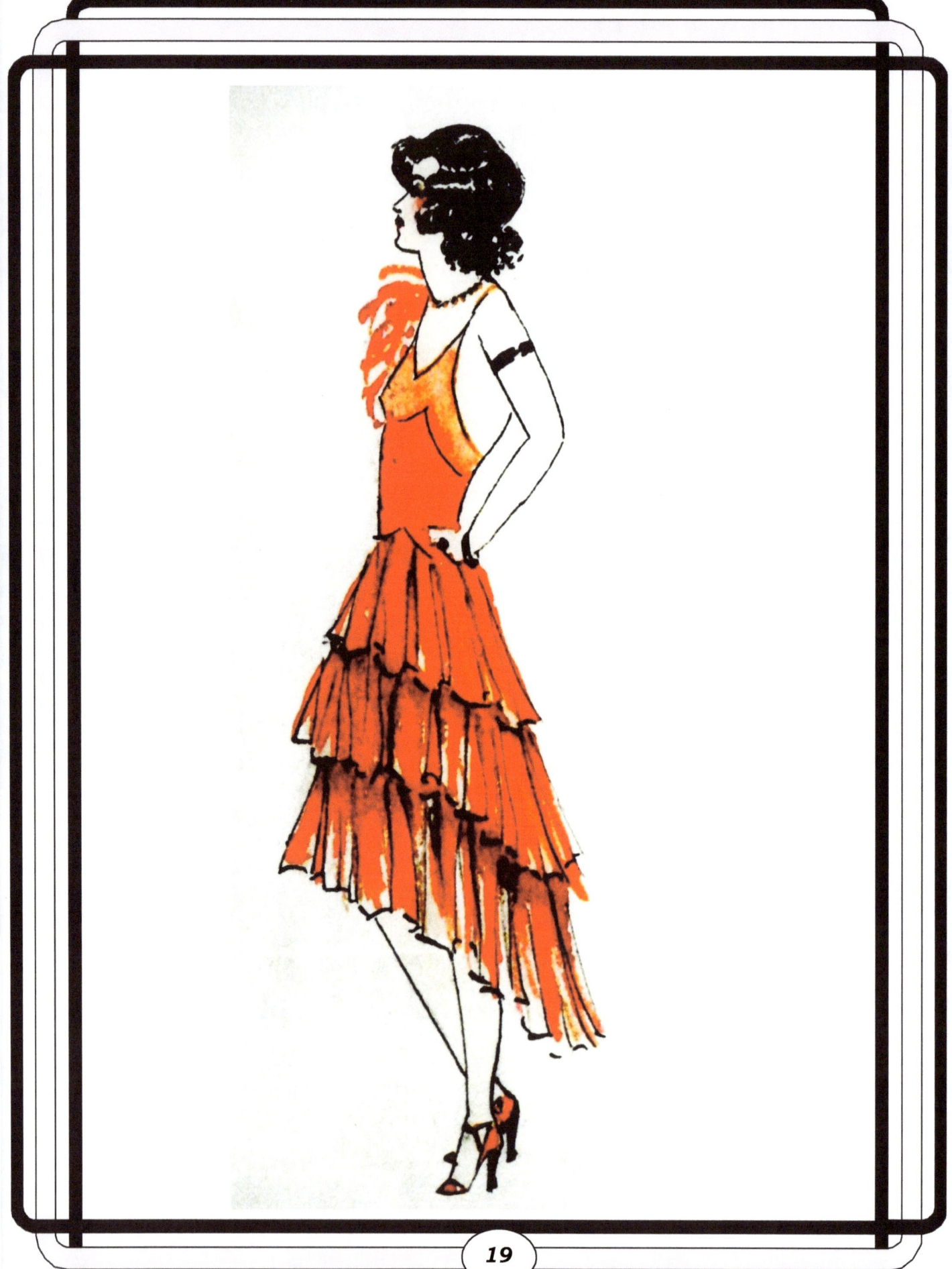

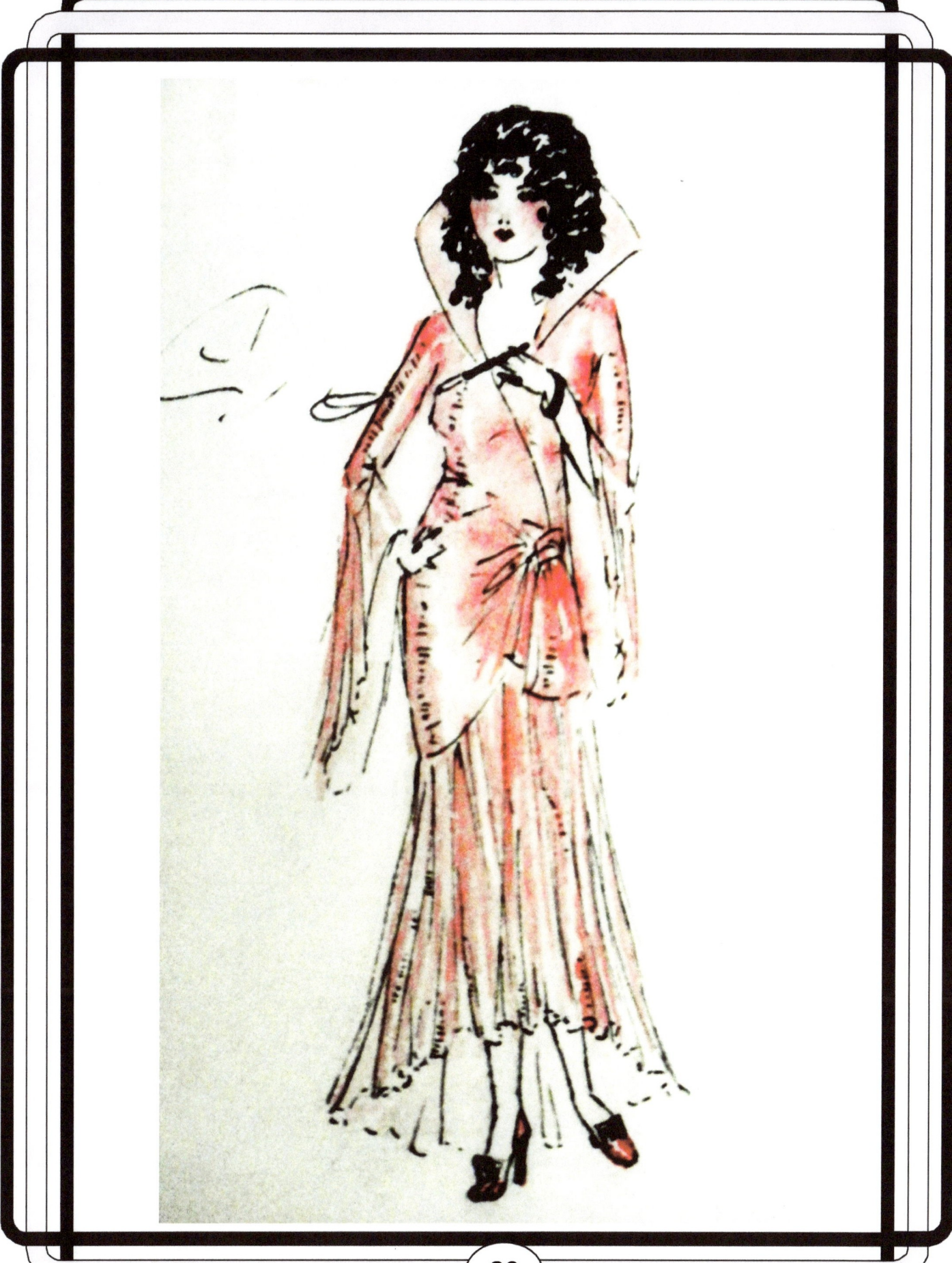

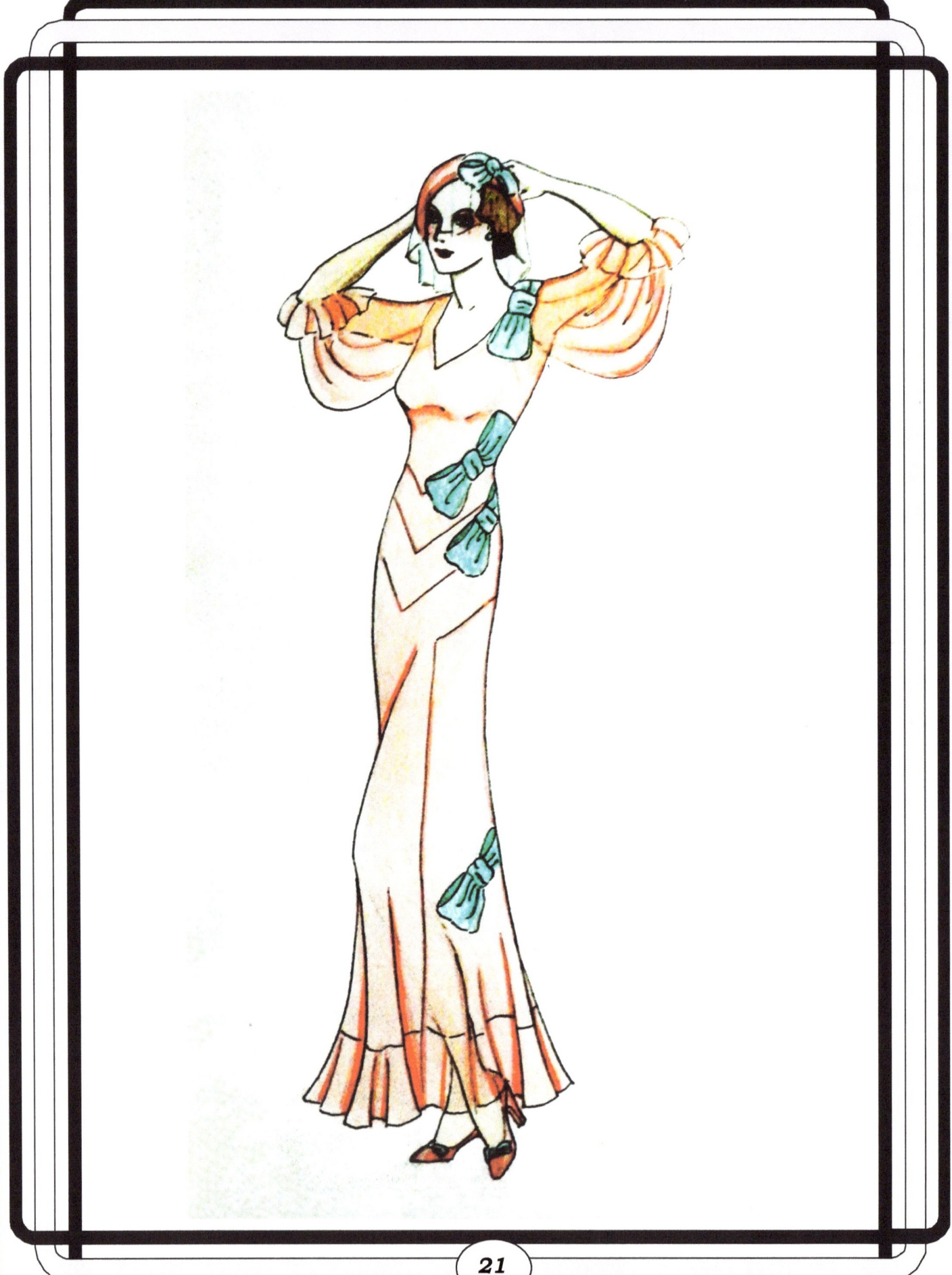

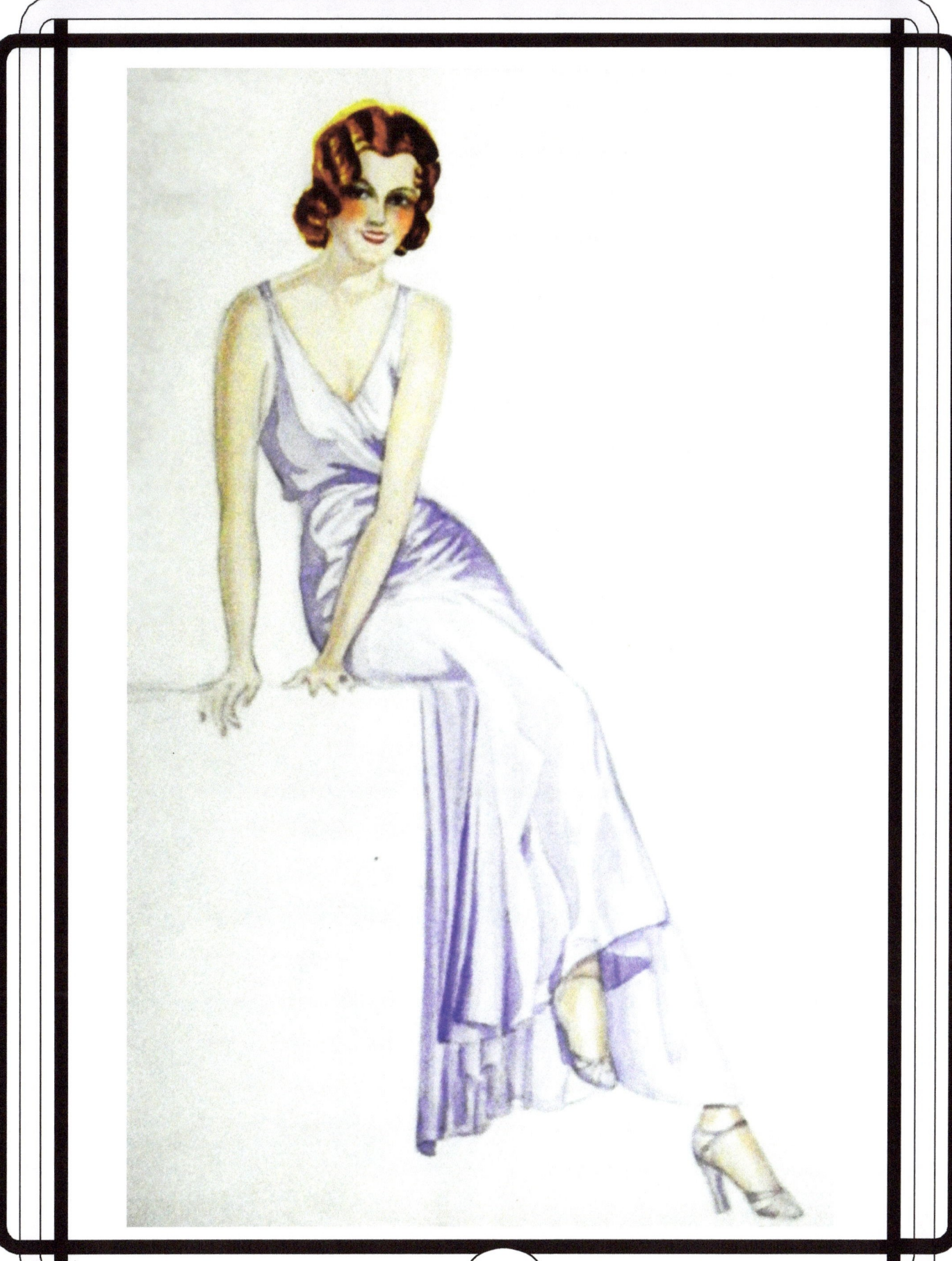

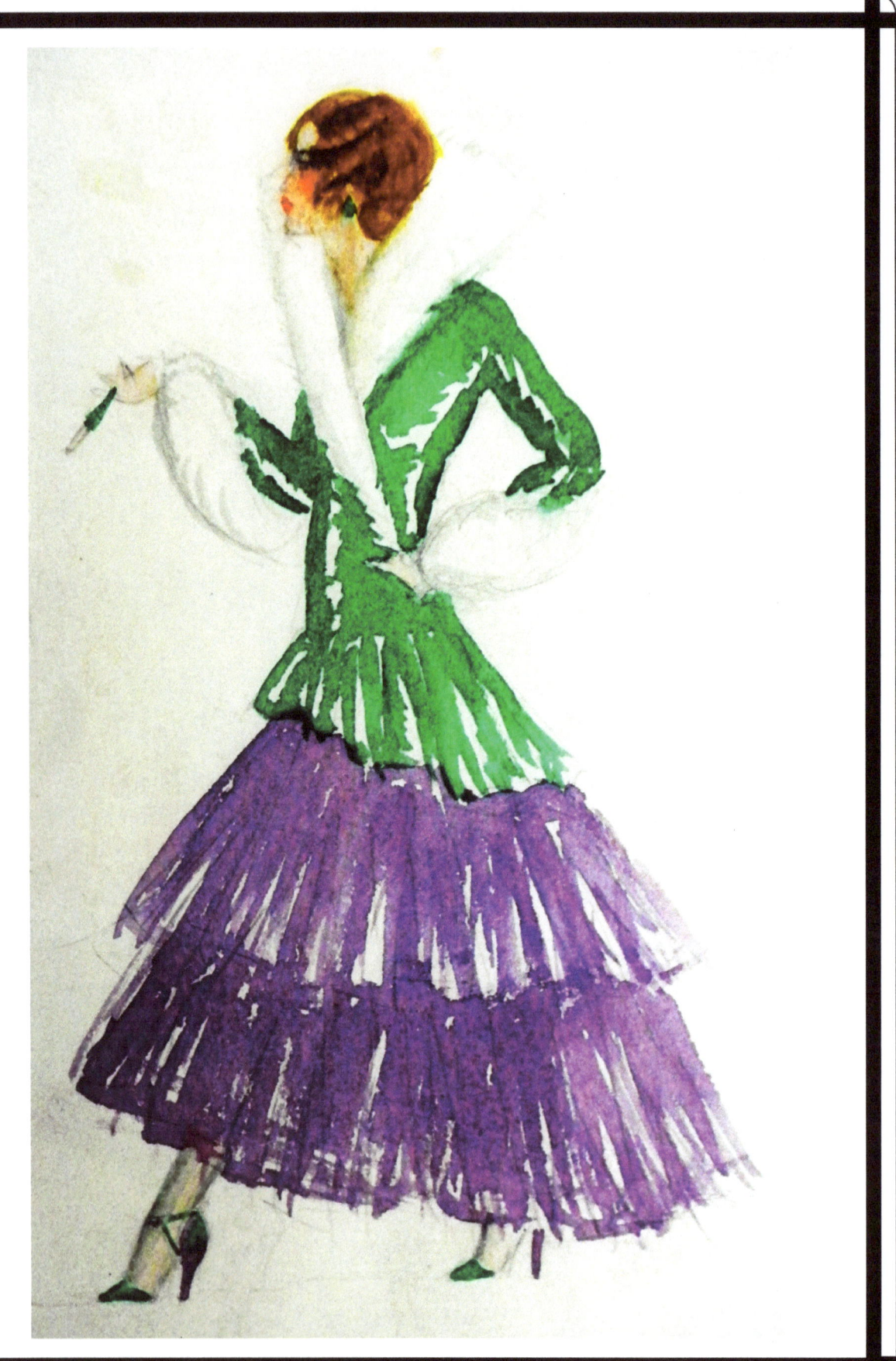

Chapter Four – Party Time!

"Gone with the Wind"
In like Errol Flynn!

Gershwin
On Broadway did a win!

***Glenn Miller's** band*
Truly grand!

Gas at ten cents a gallon,
Who needs to ride a stallion?

Party Up!
Look like sugar,
Look like spice!

Wear that fancy shawl
On top of nothing at all.

Be a ballerina
A dancing star,
Stretch for the moon, forget a big car.

This is the 1930'S you say,
The Depression slowly out of the way.

Pretend it has gone and celebrate
A time to love, a time of the bold and the great.

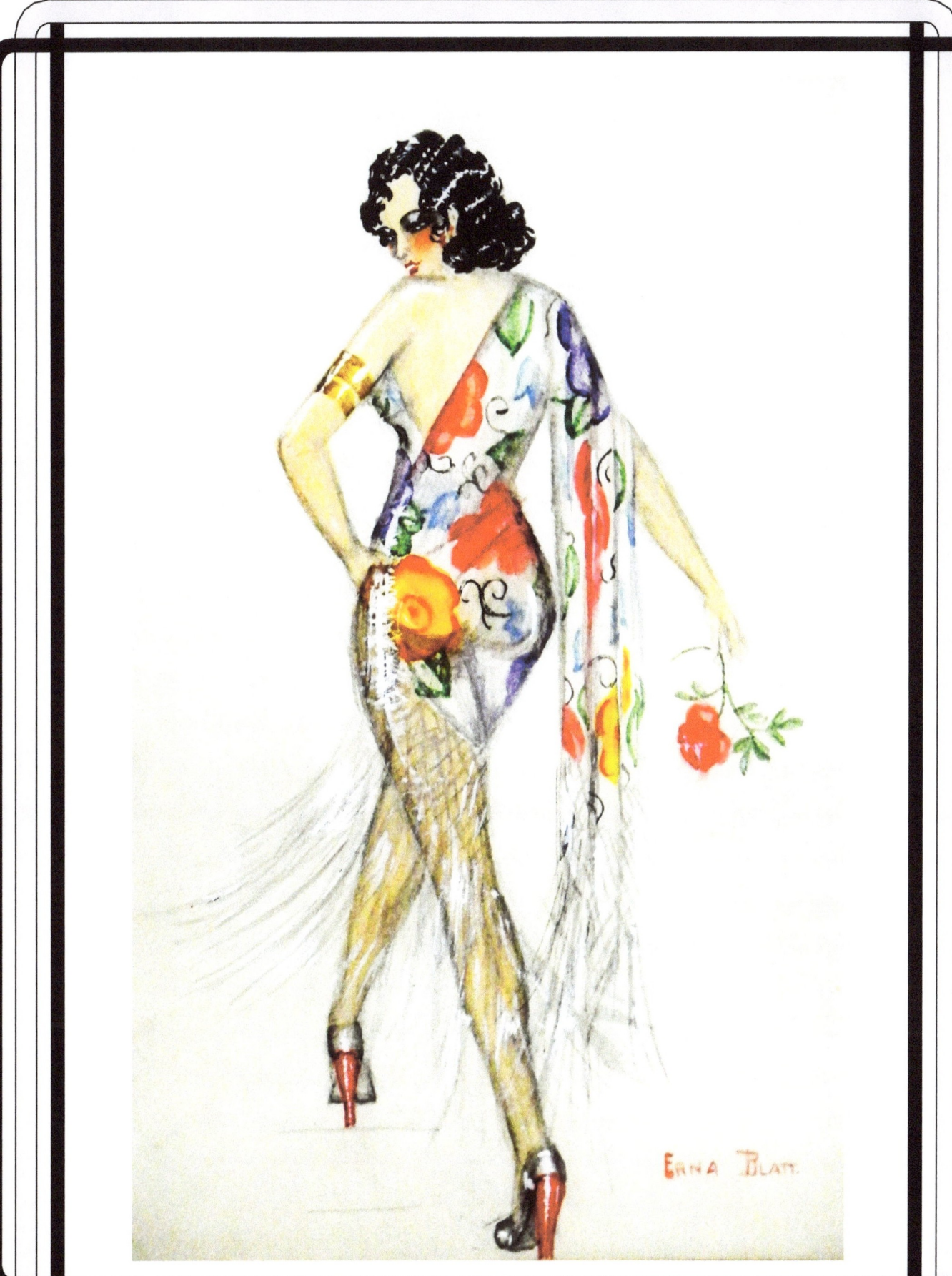

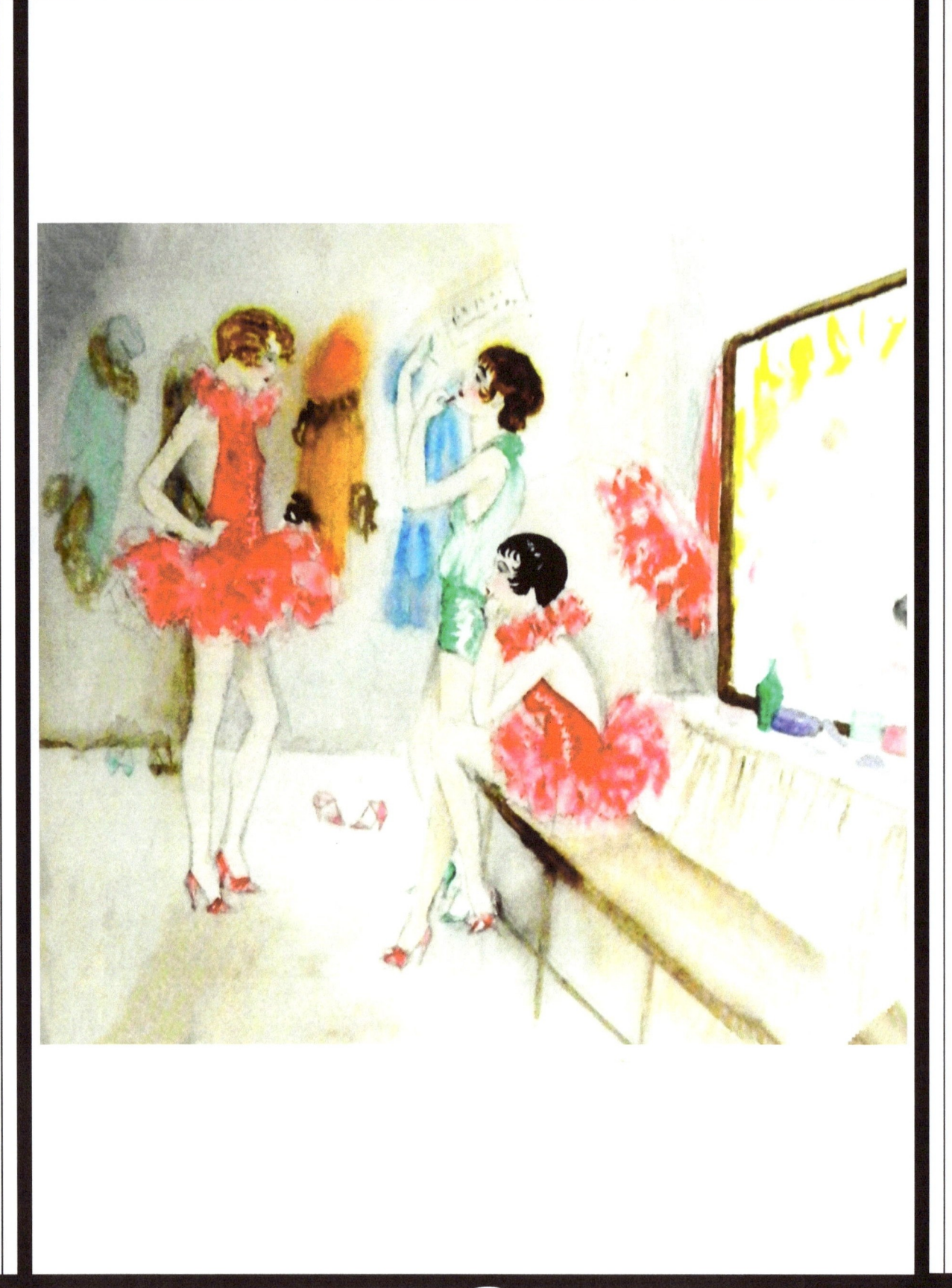

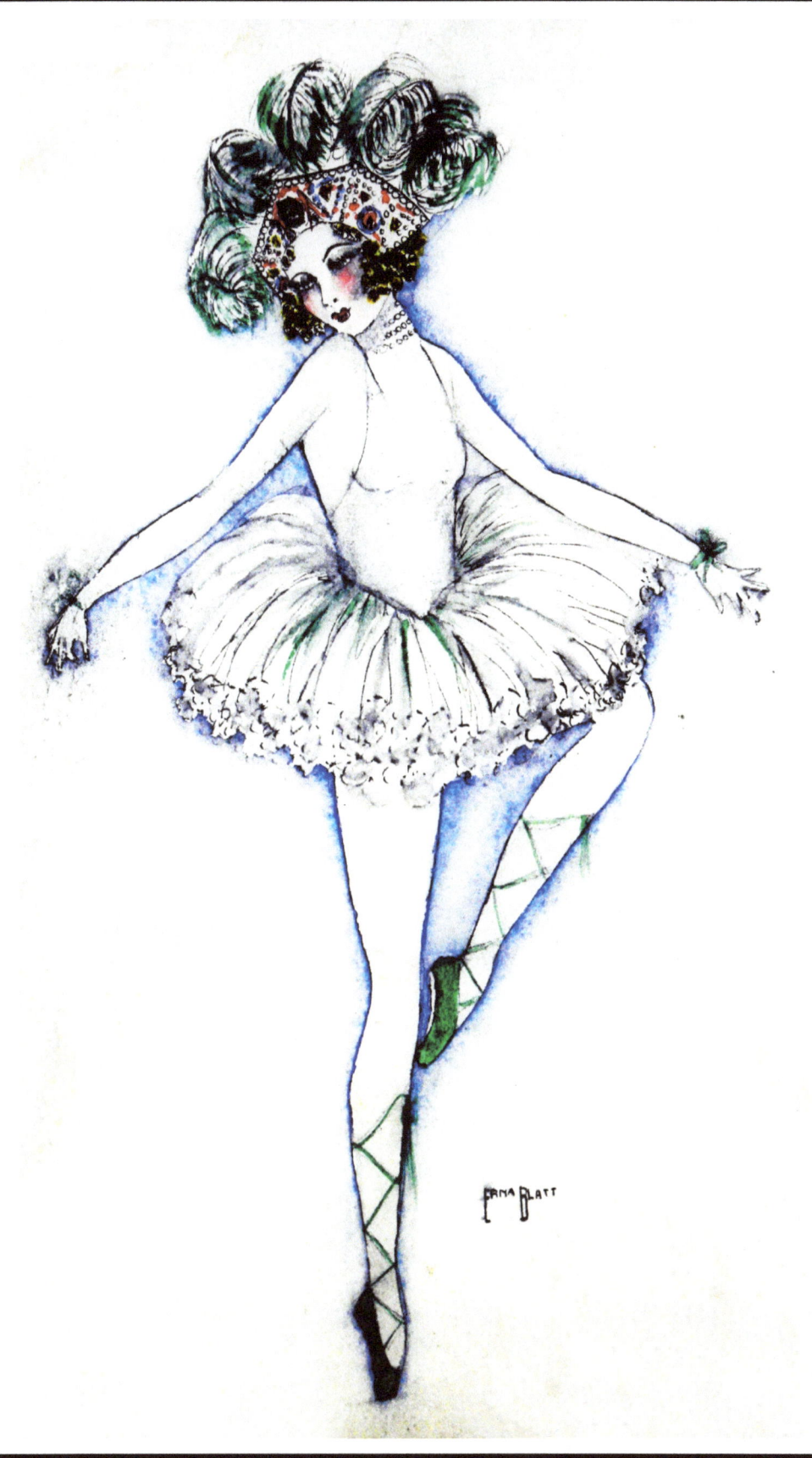

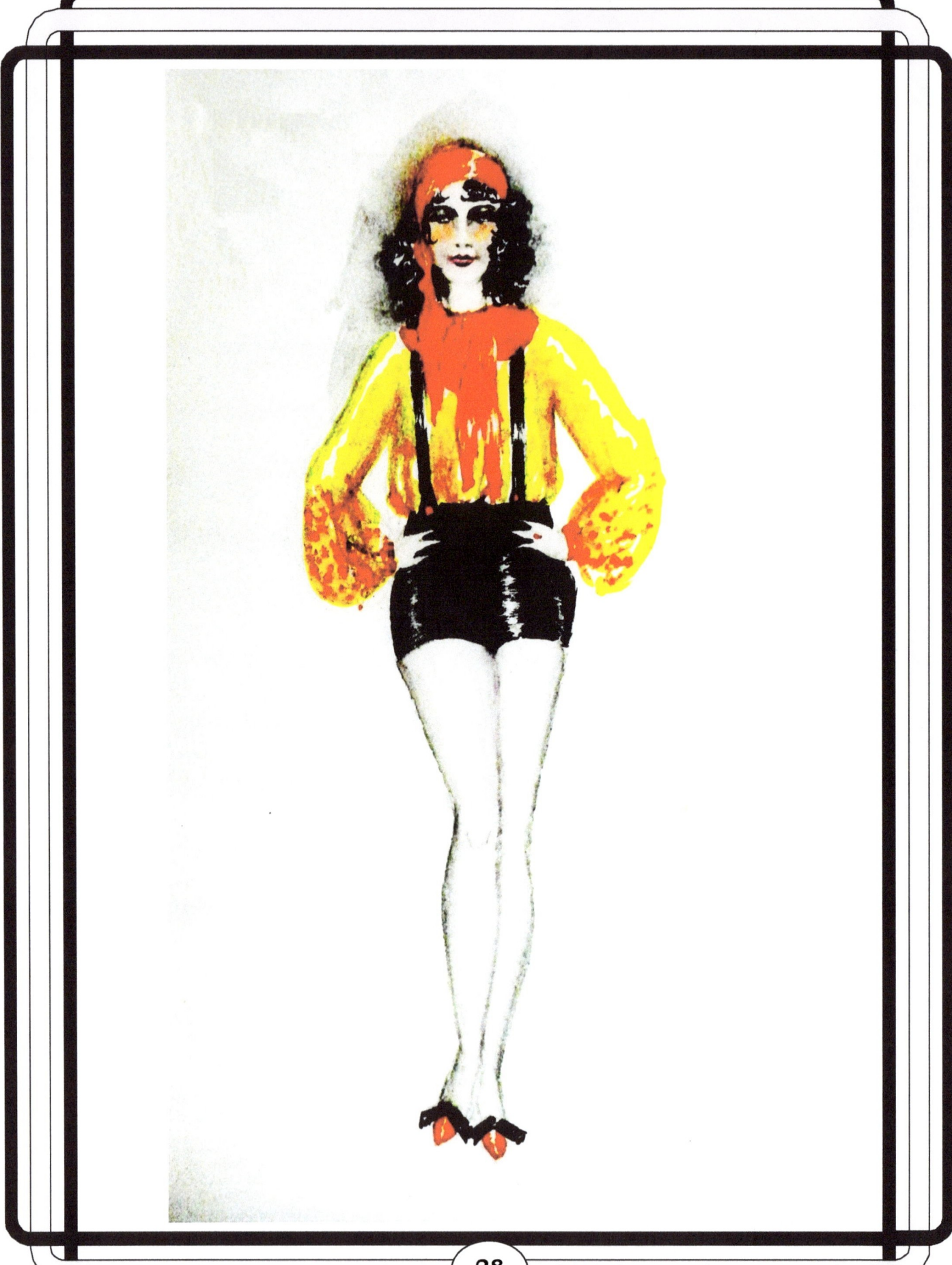

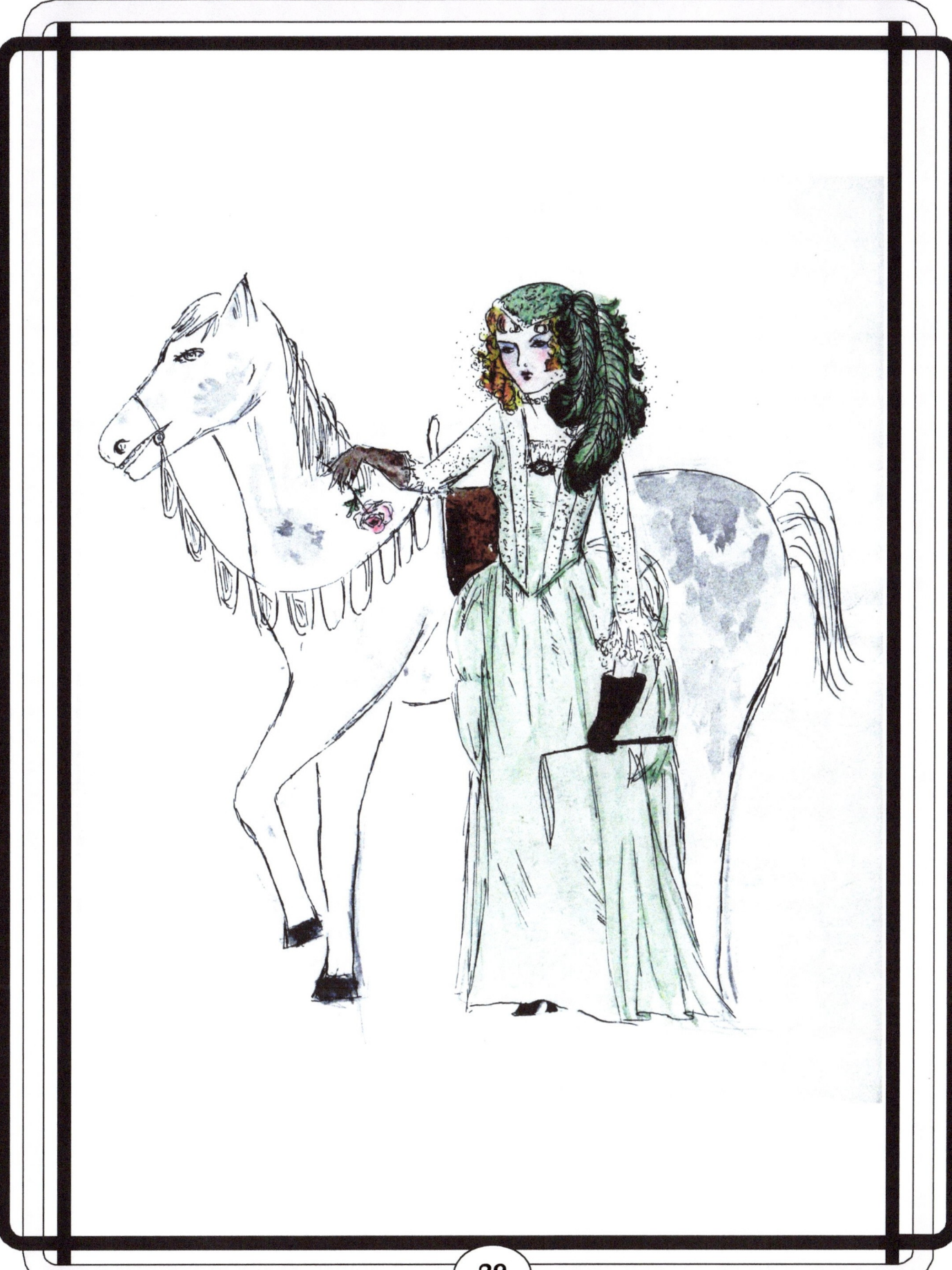

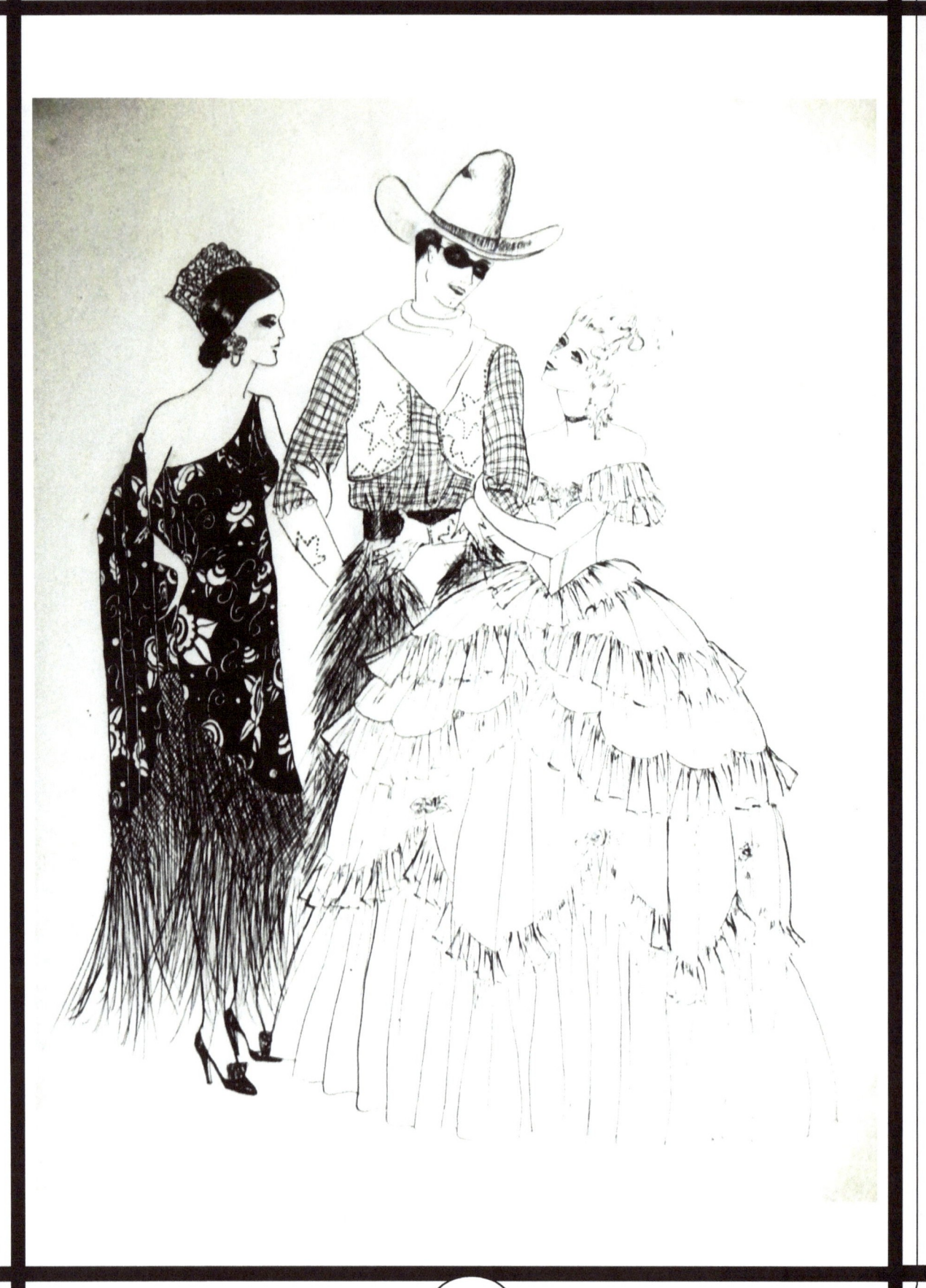

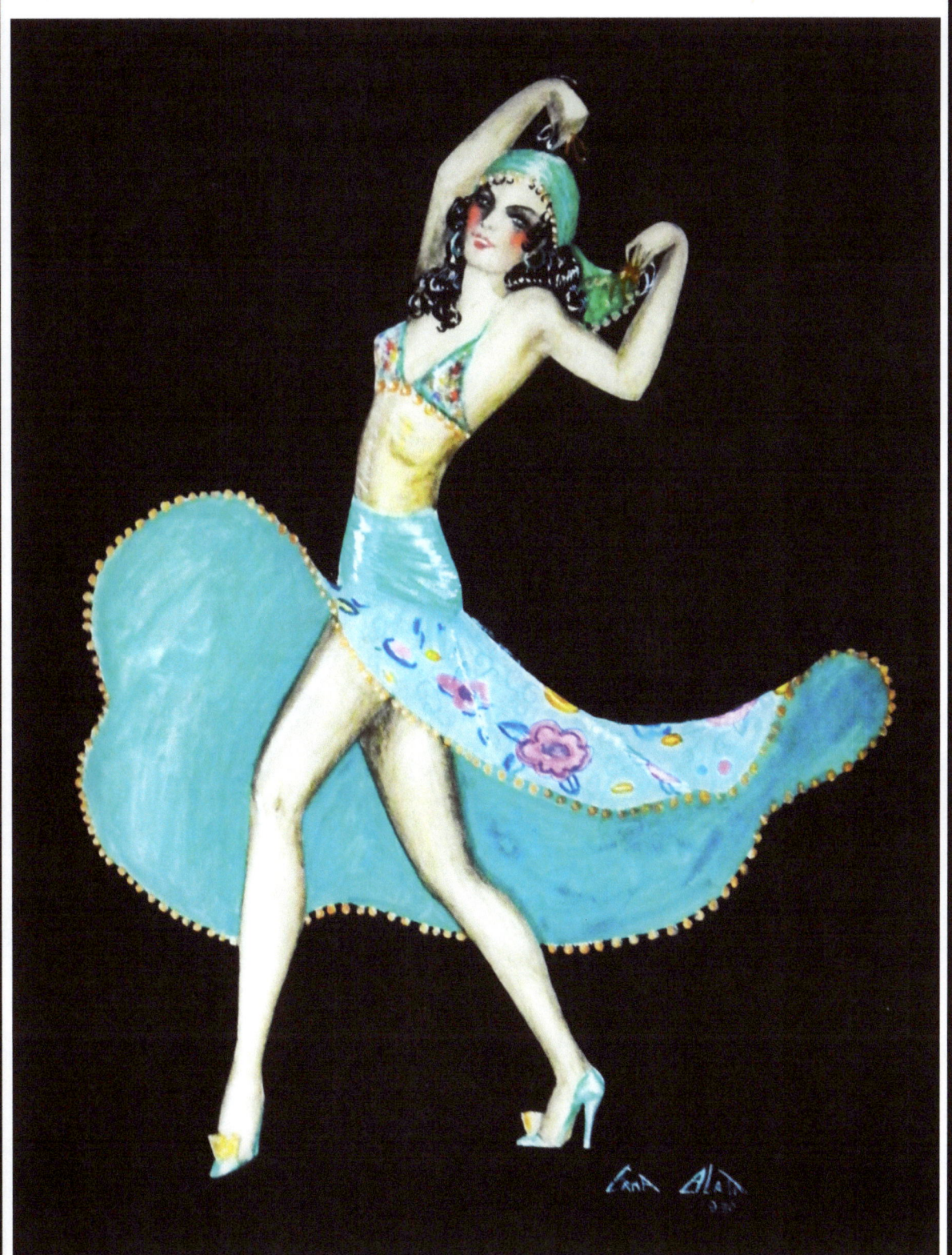

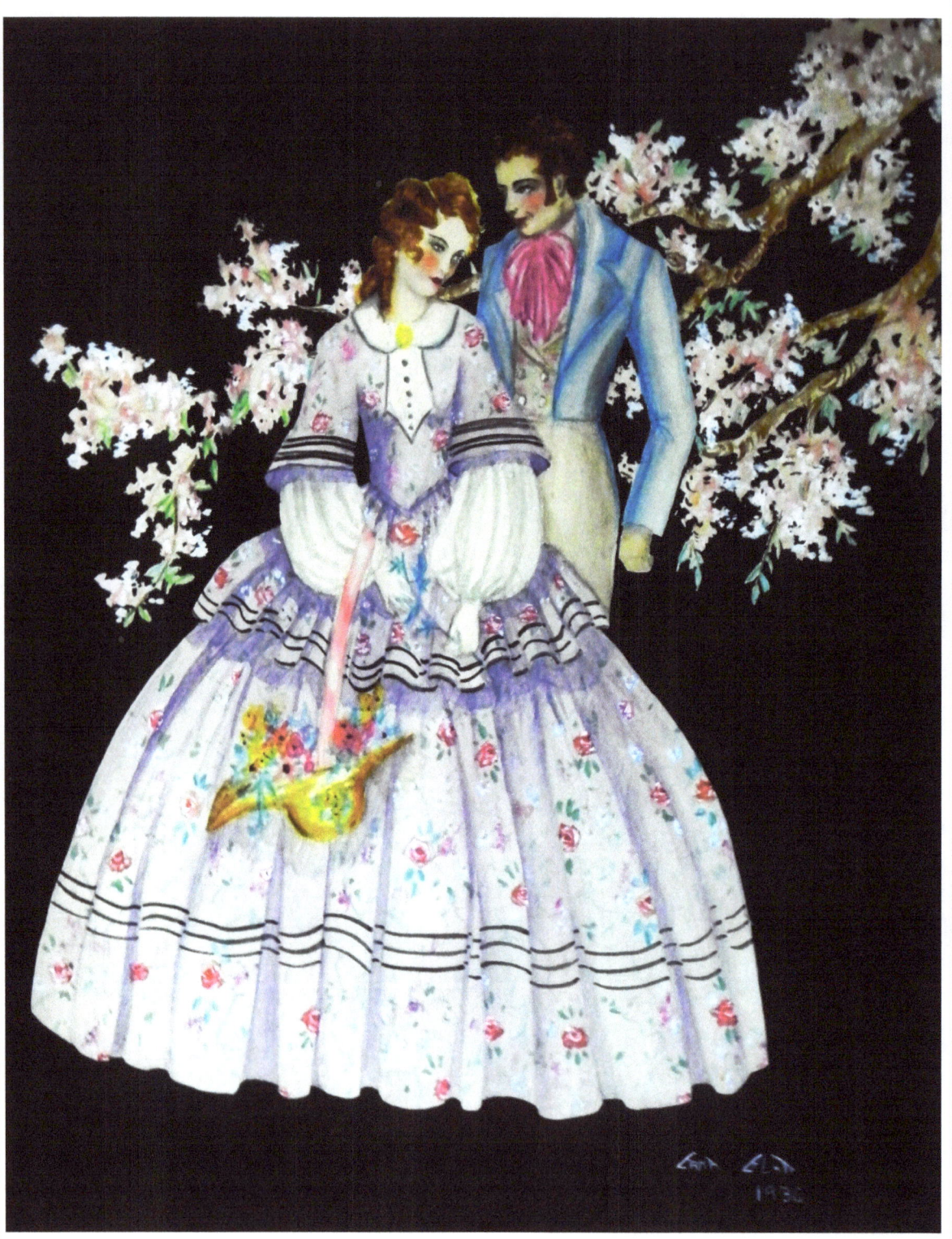

About the Author

Andrea L. Willow is an artist and writer. These self- expressions have been a part of her life from an early age. From time to time art and writing merge, as in her recently published book, "The Whole World Is Naturally Curly"*. Her wit and humor are demonstrated in "TWWINC".

Andrea has participated in art exhibitions at Los Angeles, San Bernardino County, California and Las Vegas, Nevada.

Venues were hotels, high-end boutiques, and art galleries. Andrea's art enhances the homes of many private collectors nationwide and internationally. Also, she has published articles locally in the High Desert, California.

Born in Chicago, Illinois, she moved to California with her family in 1956. She received her BA from Antioch University, has studied at the Center for Art in Pasadena, CA, and has taken many art classes and private lessons over the years.

Andrea may be contacted by email: picassotp@gmail.com

*Available at www.amazon.com; www.andreawillow.com

www.ingramcontent.com/pod-product-compliance
Lightning Source LLC
Chambersburg PA
CBHW040752200526
45159CB00025B/1867